THE BRITISH MUSEUM
HAIKU
Animals

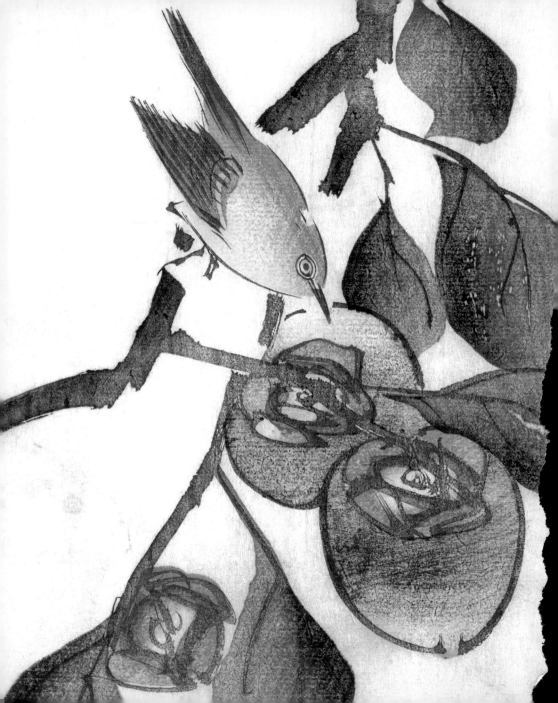

THE BRITISH MUSEUM
HAIKU
Animals

EDITED BY

Mavis Pilbeam

for a companion on this journey
I would fain have
a butterfly

Shiki

THE BRITISH MUSEUM PRESS

To Douglas and Kathleen:
haiku lovers, nature lovers, Japan lovers

I owe many thanks for their generous help and advice to British Museum
colleagues Tim Clark and Hiromi Uchida in the Japanese Section; to Lucinda Smith
and all the Museum Assistants in the Department of Asia; to Rosina Buckland
in the National Museum of Scotland; to John Carpenter, Fujiko Kobayashi,
Steve Dodd and Timon Screech of SOAS; to Ellis Tinios, Makoto Ueda,
Yuuki Yoshiara, Desmond Kerr and Robert Dabell; to the Modern Haiku
Association of Japan and to numerous friends for their support.

Mavis Pilbeam has asserted her right to be identified as the editor of this work

First published 2010 by The British Museum Press
A division of The British Museum Company Ltd
38 Russell Square, London WCIB 3QQ
britishmuseum.org/publishing
Reprinted 2011, 2012, 2013, 2014, 2015, 2018

A catalogue record for this book is available from the British Library
ISBN 978 0 7141 2461 2

Frontispiece: Ōnishi Chinnen (1792–1851), *White-eyes* (detail),
from Sonan's Picture Album no. 21, 1834. Woodblock printed book, colours on paper
Title page: Anon., *Butterfly and Cherry Blossoms* (detail), mid-nineteenth century.
Surimono woodblock print, colours on paper
Page 96: Tani Bunchō (1763–1840), *Butterfly* (detail), *c.*1820.
Collaborative hanging scroll by six bunjin painters, ink and colours on silk

Photography © The Trustees of the British Museum, by the British Museum Department
of Photography and Imaging and the Art Research Center, Ritsumeikan University, Kyoto, Japan

Designed and typeset in Centaur by Peter Ward
Printed in China by C&C Offset Printing Co., Ltd

Papers used by The British Museum Press are recyclable products made from wood
grown in well-managed forests and other controlled sources. The manufacturing
processes conform to the environmental regulations of the country of origin.

MIX
Paper from
responsible sources
FSC® C008047
www.fsc.org

INTRODUCTION

ONE WARM SUMMER's evening towards the end of the 1780s, 'the usual group of comic poets dragged one another along to listen to the voices of the insects that chirp in the field ... We spread out our rugs on the embankment of the Sumida River [in Edo, modern Tokyo] ... and tried to fix a value on the voice of each insect, high or low ... Thus we whiled away the night [till finally], turning to face these dew-covered personages, we politely bow down low.' This event is described in the preface to *A Selection of Insects*, an exquisite luxury woodblock-printed book by the celebrated 'floating world' artist Kitagawa Utamaro. We hear in the postscript by his teacher Sekien how, 'when Mr Uta was little ... he would put grasshoppers and crickets on the palm of his hand and become totally absorbed'. Thus he learnt to paint 'from the heart'. Poetry, too, according to the classical poets, 'had its seeds in man's heart'. This book, a selection of Japanese haiku poems paired with paintings, prints and carvings of animals, is a lively demonstration of how Japanese culture celebrates these heartfelt links between man and nature, between poetry and art.

A haiku usually consists of seventeen syllables in three units of 5-7-5. The form was developed by Japan's best-known poet, Matsuo Bashō (1644–1694). All seventeenth-century poets were familiar with classical anthologies such as *Manyōshū*, an eighth-century collection, and *Kokinshū*, from the Heian period (794–1185). The prominent classical form was the *tanka*, a poem of 5-7-5-7-7 syllables. Bashō often led poetry parties for the writing of *haikai no renga*, 'linked verse', where a number of poets would take it in turns to write poems of 5-7-5 and 7-7 syllables, each linking back to the preceding poet's verse. The leading 5-7-5 poem, called a *hokku*, set the season and tone for the whole sequence and it was often perfected in advance. Bashō began to produce *hokku* which could stand alone as independent poems, and over time the new form was taken up by other poets.

Besides following the 5-7-5 form, each *hokku* had to contain a *kigo*, 'season word' and a *kireji*, 'cutting word', which divided the utterance into two parts linked by a subtle tension, or gave a final sense of wonder or surprise. The

classical poets, too, had written about nature and loneliness, often referring to the seasons, to cherry blossom, wild geese in flight or fireflies, and such images appear repeatedly as *kigo* in *hokku*. Bashō also wrote about the purpose of *hokku*: the poet should 'beautify plain speech', and *hokku*, while avoiding vulgarity, should have a simplicity, a sympathy with loneliness and frailty. Above all they should demonstrate the twin concepts of essence and universality in this world, as revealed in an everyday or unexpected sight, sound, or experience. In their brevity, the poems suggest rather than convey complete meanings, and thus require an imaginative response from each listener or reader.

Even in Bashō's day, poets were not restricted by the formal rules, and haiku of twenty or more syllables occur. When counting syllables, a final 'n' in Japanese counts as one syllable and long vowels take two syllables: thus, the names of the poets Bashō and Buson have three syllables each.

After a second flowering of *hokku* in the late eighteenth century, with the drama of Yosa Buson and the compassion of Kobayashi Issa, there was a sharp decline until the revival led by Masaoka Shiki (1867–1902). It was Shiki who coined the term *haiku*. These later poets often broke with tradition, and their steeliness and humour bring a more down-to-earth element to this anthology.

Man and nature, poetry and art

IN JAPAN, affinity with nature has always been highly valued in the culture, informing daily life, religious practices, literature and art. This sympathy can be traced back to prehistoric times when as hunters and gatherers, people seem to have lived in harmony with their surroundings and the changing seasons. The seasons still influence daily life: clothes, furnishings and pictures are changed accordingly; traditional houses open on to verdant gardens, and sliding paper-covered doors filter in the light even when closed, unifying exterior and interior spaces. The Shintō religion has fostered a respect for all natural things, while Buddhist awareness of impermanence and change brings a pervasive sense of melancholy. The poet Shinkei (1406–1475) commented that anything written without an awareness of this Buddhist truth 'cannot truly hold deep feeling'.

Just as haiku are incomplete, inviting a creative leap from the reader, so Japanese animal paintings and prints often require a similar engagement. Typically, the Japanese artist places his subject in a barely suggested landscape: the balance between the motif and its surrounding space is an essential part of his artistry. The creature depicted is not one particular animal in its specific setting, but becomes a representative of its kind in an evocative context. Thus, both artist and poet produce realistic images which are yet imbued with subtly fanciful suggestions of the universal: Gyokudō's deer is the universal lone animal as it turns its back and moves away; Bashō's deer is the solitary being in the night.

Morning, noon and night

IN MANY HAIKU collections, the poems are arranged in sequence through the seasons. This book breaks with tradition and takes the reader on an imaginary journey through one day. It starts in a mood of excitement as the traveller attires himself and sets out; he passes through a watery landscape in which he shivers with cold. The temperature rises to noonday heat; then the traveller moves on with flying geese, a lumbering cow, to reach the melancholy mood of evening, and is finally enveloped in night, the kingdom of insects and cats in love. In most cases, the haiku are linked, somewhat in the manner of a *renga* linked verse, but the links can refer back and forth across time – through the eyes of frog, snake and hawk, through the voices of rooster, skylark and singing insect.

The layout of the Japanese text carefully reflects its meaning, as a Japanese calligrapher would write it with a brush. Remember, too, that haiku are poems which should be read aloud to hear their 'tight music': this is the best way to return to the moment of revelation which inspired each one. Above all, the underlying feeling throughout is of deep sympathy with every inhabitant of the animal world, as keenly expressed by Issa:

> don't kill the fly!
> see how it wrings its hands,
> its feet!

THE DAY BEGINS

omowazu mo hiyoko umarenu fuyu sōbi

unexpectedly
a chick has hatched –
midwinter rose

Kawahigashi Hekigodō

思わずも
ヒヨコ生れぬ
冬薔薇

chikara ippai ni naku ko to naku niwatori to no asa

a morning
of babies crying,
of roosters crowing,
with all their might

Ogiwara Seisensui

力いっぱいに
泣く子と
鳴く鶏
との朝

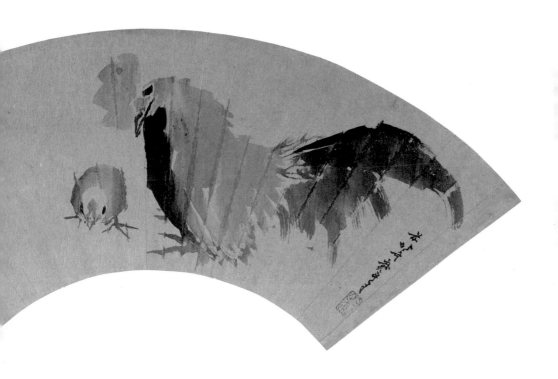

Katsushika Hokusai (1760–1849), *Cockerel and Chick*, 1815–20
Fan leaf painting, ink and colour on mica-covered paper

9

hatsushigure saru mo komino wo hoshigenari

first winter rain;
the monkey also seems to wish
for a small straw rain-coat

Bashō

初時雨
猿も小蓑を
欲しげなり

toshidoshi ya saru ni kisetaru saru no men

year after year —
the monkey wearing
a monkey's mask

Bashō

年々や
猿に着せたる
猿の面

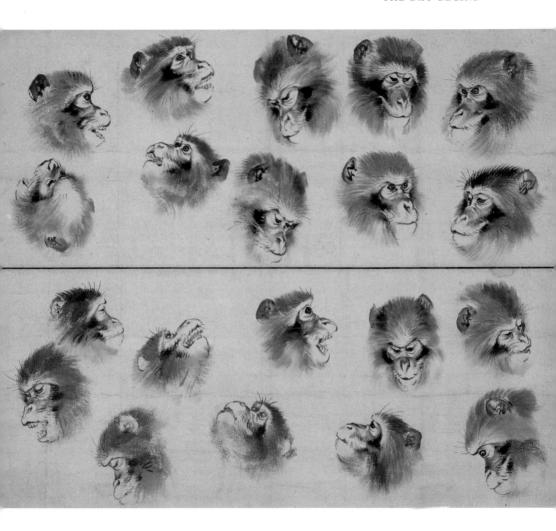

Mori Sosen (1747–1821), *Twenty Studies of Facial Expressions of Macaque Monkeys*,
late eighteenth–early nineteenth century. Hanging scroll painting, ink on paper

tabi-sugata shigure no tsuru yo Bashō-ō

in travelling attire
a crane in late autumn rain:
the old master Bashō

Chora

旅姿
時雨の鶴よ
芭蕉翁

hi no haru wo sasuga ni tsuru no ayumi kana

on New Year's dawn,
sedately, the cranes
pace up and down

Kikaku

日の春を
さすがに
鶴の
歩み哉

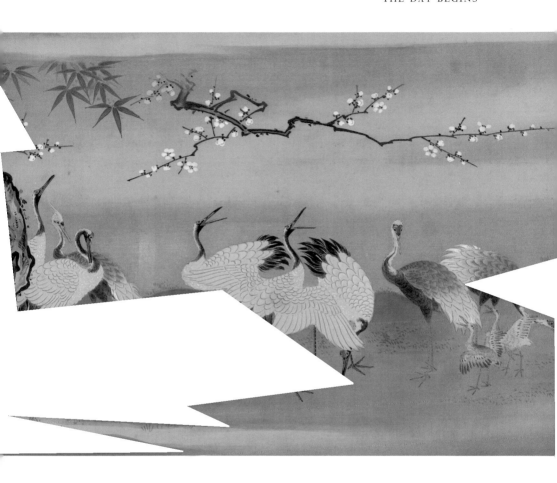

Kano Eisen'in Michinobu (1730–1790), *Cranes with Pine, Bamboo and Plum* (detail),
mid-eighteenth century. Handscroll painting, ink and colours on silk

higoro nikuki karasu mo yuki no ashita kana

usually hateful,
yet the crow too
in this dawn snow

Bashō

烏
も

雪
の
朝
哉

ひ
ご
ろ
憎
き

Koson Ohara (1877–1945), *Crow on Snowy Willow Branch*, 1911
Hanging scroll painting, ink and colours on silk

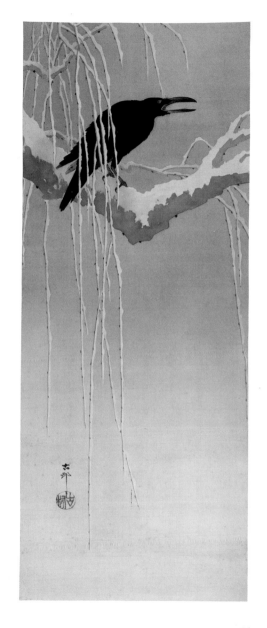

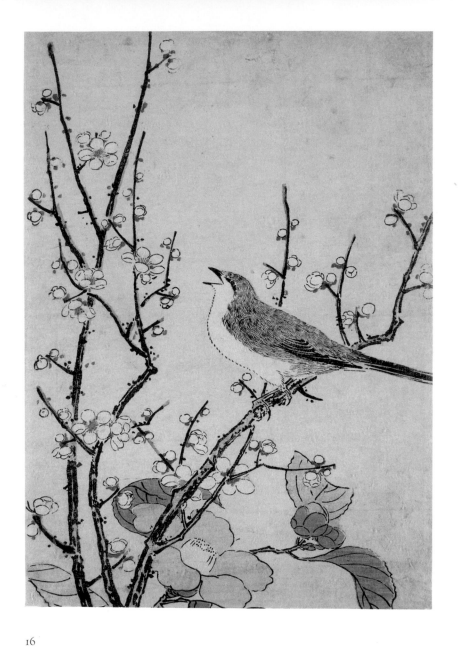

uguisu ya haya hitokoe no shitarigao

so the warbler comes
right on time with a single song
and a knowing look

Keiseki

鶯や
はや一声の
したりかほ

Isoda Koryūsai (1735–1790), *Warbler with Plum and Camellia, c.*1770
Woodblock print, colours on paper

asakaze no ke wo fukimiyuru kemushi kana

the morning breeze
seen blowing the hairs
on the caterpillar

Buson

毛
虫
か
な

朝
風
の
毛
を
吹
見
ゆ
る

uraraka ni kemushi wataru ya matsu no eda

under the bright sky
a hairy caterpillar crawls
on the pine tree's branch

Akutagawa Ryūnosuke

う
ら
ら
か
に

毛
虫
わ
た
る
や

松
の
枝

Kitagawa Utamaro (*c.*1754–1806), *Hairy Caterpillar* (detail), from *Selected Insects*, vol.1, 1788
Illustrated woodblock printed book, colours on paper

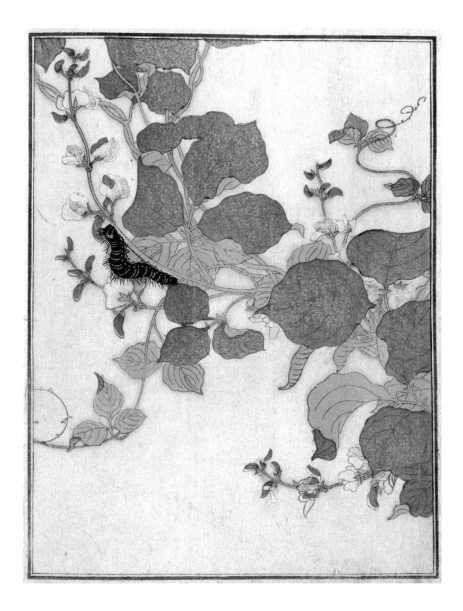

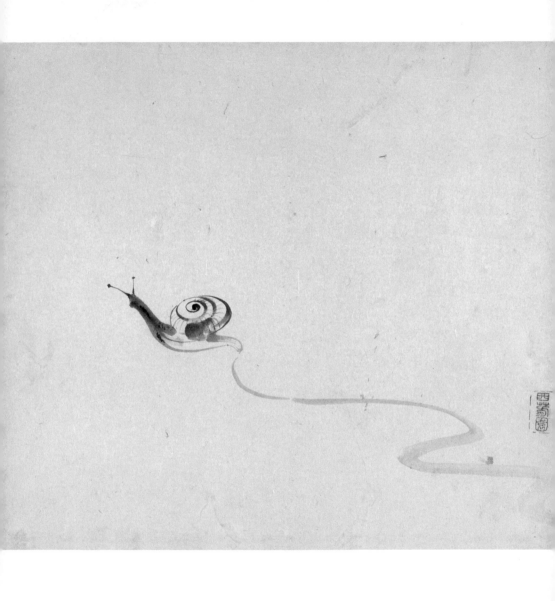

katatsumuri sorosoro nobore fuji no yama

O snail
climb Mount Fuji,
but slowly, slowly

Issa

富士の山　そろそろのぼれ　蝸牛

Nishiyama Hōen (1804–1867), *Snail*, nineteenth century
Album leaf painting, ink and colours on paper

kata ni kite hito natsukashi ya aka-tonbo

it comes to my shoulder
longing for human company:
a red dragonfly

Natsume Sōseki

赤
蜻
蛉

肩
に
来
て
人
な
つ
か
し
や

ono ga mi ni aki wo somenuku tonbo kana

he has dyed his body
with Autumn –
the dragonfly

Bakusui

己
が
身
に
秋
を
染
め
抜
く
蜻
蛉
哉

Morita Kakō (worked *c*.1900), *Dragonfly on Stalk of Rush*, *c*.1900
Woodblock print, colours on paper

22

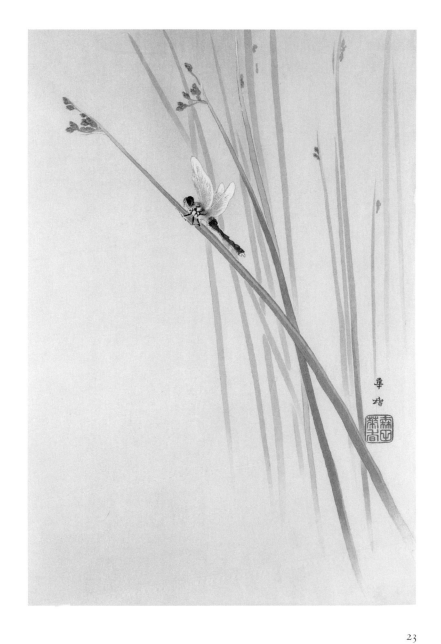

MORNING WATERSIDE

yūdachi ya kaeru no tsura ni mitsubu hodo

summer shower
about three drops
on the frog's face

Shiki

夕
立
や

蛙
の
面
に

三
粒

ほ
ど

ichimen no rakka no mizu ni kaeru no me

all over the water
fallen blossoms spread, and amongst them
a frog's eyes

Tomiyasu Fūsei

一
め
ん
の

落
花
の
水
に

蛙
の

眼

Kitagawa Utamaro (c.1754–1806), *Frog Looking at its Mate's Reflection*, 1788
from *Selected Insects*, vol. 2. Illustrated woodblock printed book, colours on paper

ginkōinra asa yori keikō su ika no gotoku

like squids
bank clerks are fluorescent
from the morning

Kaneko Tōta

銀
行
員
等
朝
よ
り
蛍
光
す
烏
賊
の
ご
と
く

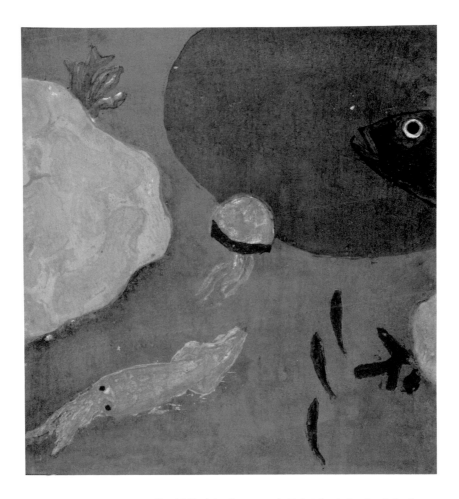

Onchi Kōshirō (1891–1955), *Fish, Jellyfish, Squid and Coral*, 1937
Colour woodblock print, right section of a triptych

isochidori ashi wo nurashite asobikeri

the plovers of the shore
played about
wetting their feet

Buson

磯
千
鳥
足
を
ぬ
ら
し
て
遊
び
け
り

urakaze ya tomoe wo kuzusu murachidori

with the wind in the bay
the plovers' formation loses
its comma design

Sora

浦
風
や
む
ら
千
鳥
巴
を
く
づ
す

Seiko (worked c.1900), *Plovers by the Shore*, c.1900
Woodblock print, colours on paper

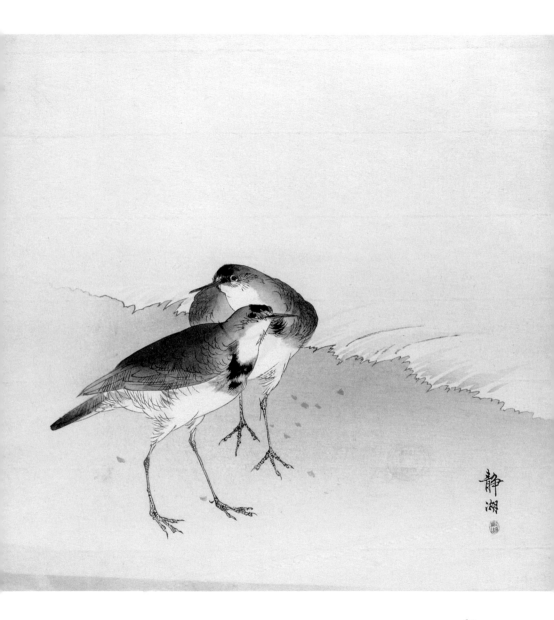

静
湖

29

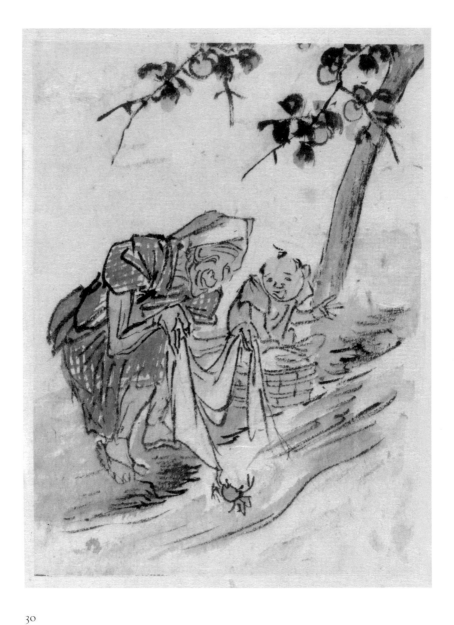

sazare-kani ashi hainoboru shimizu kana

a tiny crablet
climbs up my legs
in the clear water

Bashō

清水哉

足
這
ひ
の
ぼ
る

さ
ざ
れ
蟹

Kagawa Hōen (worked *c*.1868–1912), *Crablet with Old Woman and Child doing the Washing*,
nineteenth century. From an album of 154 paintings, colours on paper

harusame ya koiso no kogai nururu hodo

spring rain,
enough to wet the little shells
on the small beach

Buson

春雨や
ぬるゝほど
小磯の小貝

mizu samuku neiri kanetaru kamome kana

water so cold
it was hard for even a gull
to fall asleep

Bashō

水寒く
寝入りかねたる
鴎かな

Kagawa Hōen (worked *c.*1868–1912) *Gulls with Shells*, nineteenth century
From an album of 154 paintings, colours on paper

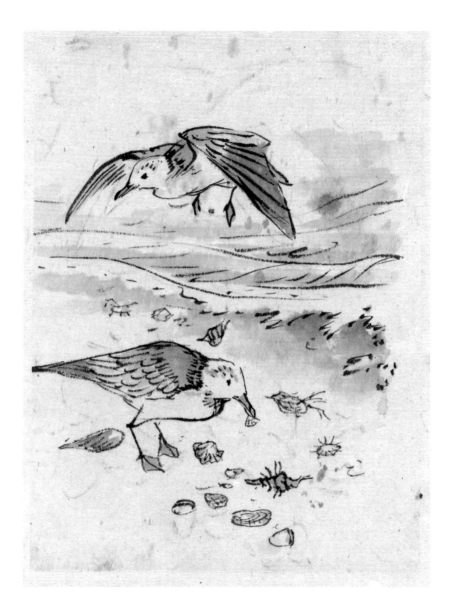

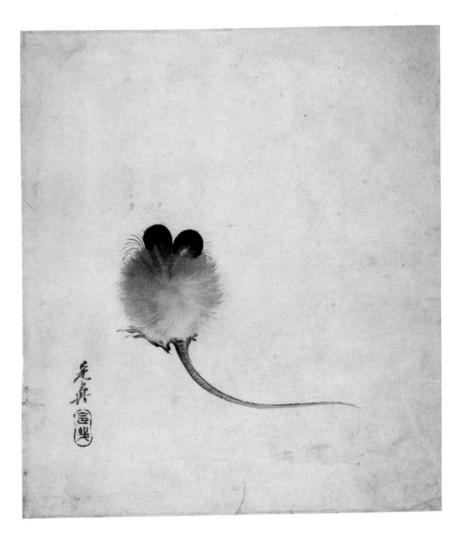

Shibata Zeshin (1807–1891), *Mouse*, nineteenth century
Painting, lacquer on paper

toshi yoreba nezumi mo hikanu samusa kana

when you grow old
even mice avoid you –
how cold it is!

Sonome

年
寄
れ
ば

鼠
も
引
か
ぬ

寒
さ
哉

nowaki shite nezumi no wataru niwatazumi

a mouse
crossing a puddle
in the autumn tempest

Buson

に
わ
た
ず
み

野
分
し
て

鼠
の
渡
る

inoshishi mo tomo ni fukaruru nowaki kana

wild boars too
are blown along:
autumn windstorm

Bashō

猪
も

共
に

吹
か
る
る

野
分
か
な

Minzan (worked *c.*1851–1869), *Boar*, 1851
Hanging scroll, ink and colours on paper

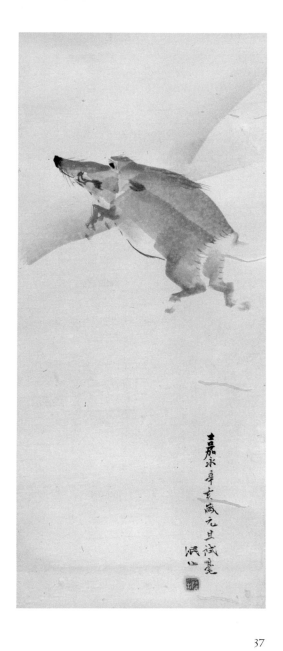

HIGH NOON

hototogisu kyō ni kagirite dare mo nashi

a hototogisu* is calling
but today, just today,
no one is here

Shōhaku

tanpopo tanpopo sunahama ni haru ga me wo aku

dandelions,
dandelions
on the sandy shore —
spring
opens its eyes

Ogiwara Seisensui

時鳥
けふに限りて
誰もなし

たんぽぽたんぽぽ
砂浜に
春が目を開く

*The Japanese *hototogisu* is a bird of the same family as the European cuckoo.

Hokusai (1760–1849), *Cuckoo and Dandelions*, 1796
Untitled woodblock printed album, colours on paper

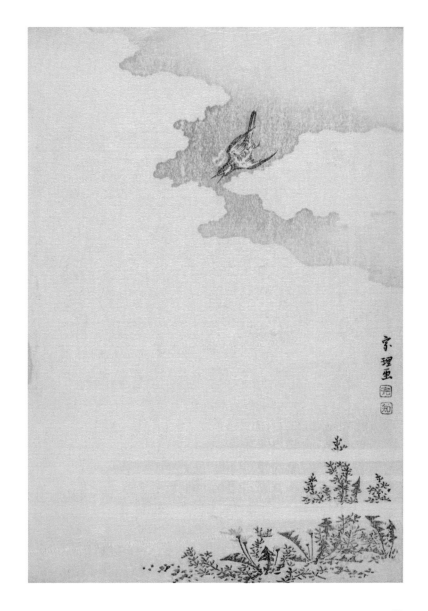

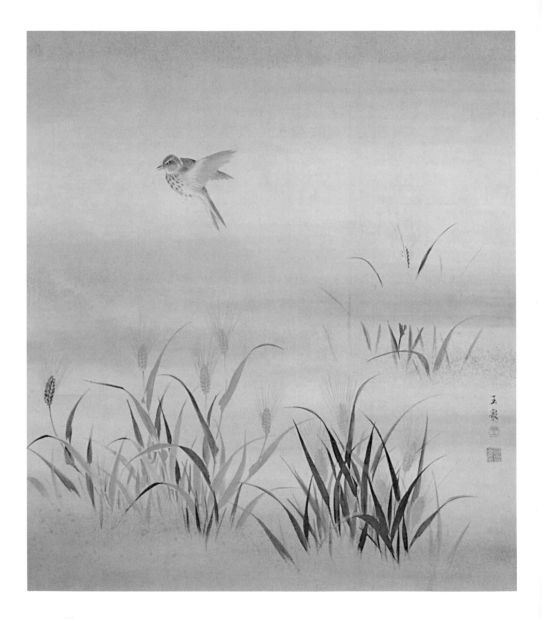

kusamugi ya hibari ga agaru are sagaru

above the young barley
see the skylark ascending –
oh no! descending!

Onitsura

雲雀があがる

あれさがる

草麦や

nagaki hi mo saezuri taranu hibari kana

all the long day
singing, singing, yet not enough:
a skylark

Bashō

ひばり哉

囀り足らぬ

永き日も

Mochizuki Gyokuzen IV (1834–1913), *Skylark Rising from Barley*,
late nineteenth–early twentieth century
Hanging scroll painting, ink, colours and gold on silk

tōyama no tsuki ni utsuru tonbo kana

far-off mountain peaks
reflected in its eyes:
the dragonfly

Issa

遠山の
目玉にうつる
蜻蛉かな

chō no shita zenmai ni niru atsusa kana

the butterfly's tongue
resembles a steel spring –
what a hot day!

Akutagawa Ryūnosuke

蝶の舌
ゼンマイに
似る
暑さかな

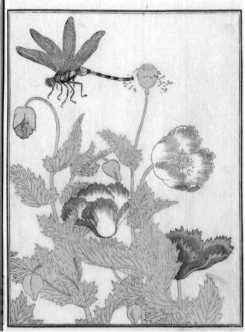

Kitagawa Utamaro (c.1754–1806), *Butterflies and Dragonfly*, 1788
from *Selected Insects*, vol. 1. Illustrated woodblock printed book, colours on paper

usagi mo *kata-mimi taruru* *taisho kana*

even the rabbit
droops one of her ears —
midsummer heat!

Akutagawa Ryūnosuke

兎
も
片
耳
垂
る
る
大
暑
か
な

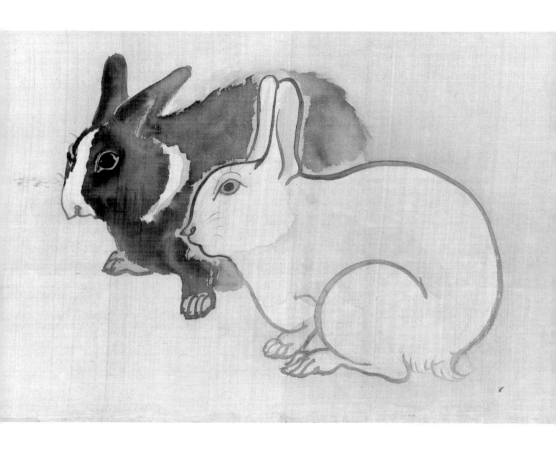

Kawamura Bunpō (1779–1821), *Rabbits* (detail) from *Handscroll of Japanese Subjects*, *c.*1807
Painting, ink and colours on paper

tōrō ni tōrō no gotoku waga te wo tatsu

at a mantis
I brandish my hand — like
a mantis

Katō Shūson

蟷螂に　　蟷螂のごとく　わが手を立つ

karikarito tōrō hachi no kao wo hamu

with a crunching sound
the praying mantis devours
the face of a bee

Yamaguchi Seishi

かりかりと　蟷螂　蜂の顔を食む

46

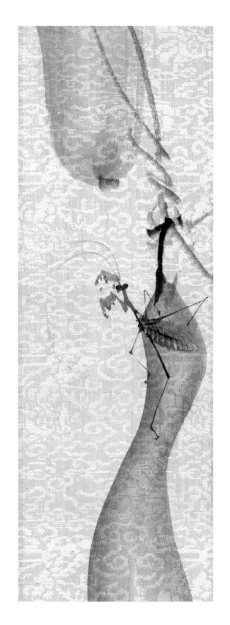

Tsuji Hōzan (worked 1822–1837),
Praying Mantis and Gourds (detail),
nineteenth century
Hanging scroll painting, ink and
colours on figured satin

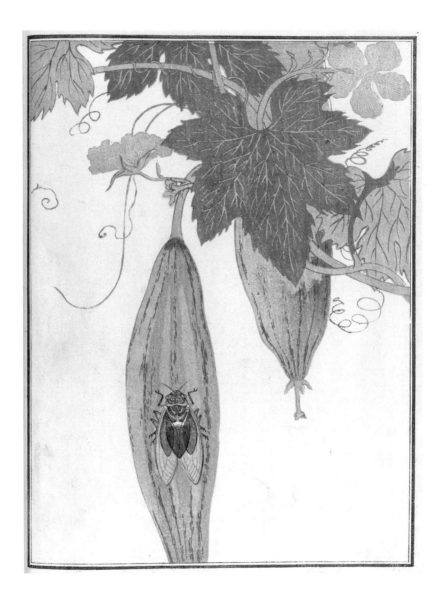

yagate shinu keshiki wa miezu semi no koe

it gives no sign
that it knows its death is near
the cicada's cry

Bashō

やがて死ぬ
けしきは見えず
蝉の声

towa ni ikitashi onna no koe to semi no ne to

how I wish to live
forever! A woman's voice
and a cicada's cry

Nakamura Kusatao

永久に生きたし
女の声と
蝉の音と

Kitagawa Utamaro (c.1754–1806), *Cicada and Grasshopper* (detail),
from *Selected Insects*, vol. 2, 1788. Illustrated woodblock printed book, colours on paper

kagerō ni kodomo asobasu kitsune kana

in a shimmer of air
the fox cubs are allowed to play
while the parent looks on

Bonchō

狐哉　子供あそばす　野馬に

Kagawa Hōen (worked *c.*1868–1912), *Fox with Cubs*, nineteenth century
From an album of 154 paintings, colours on paper

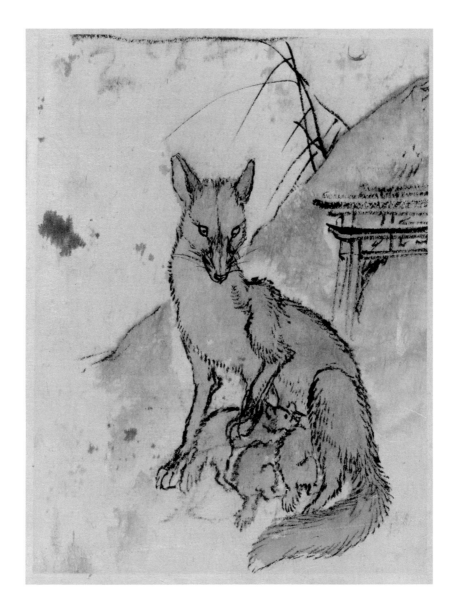

suzume-go ya akari shōji no sasa no kage

baby sparrows:
on the paper window
shadows of dwarf bamboo

Kikaku

雀
子
や

明
か
り
障
子
の

笹
の
陰

tatami wo aruku suzume no ashioto wo shitte iru

the footsteps of a sparrow
walking on the tatami floor
sound familiar

Ozaki Hōsai

畳
を
歩
く

雀
の
足
音
を

知
っ
て
居
る

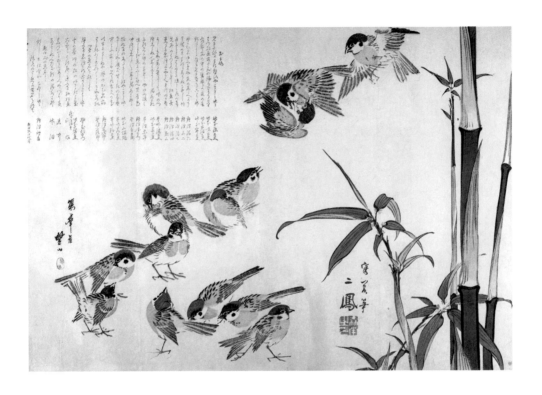

Mori Niho (1819– ?) and Sozan (dates unknown), *Sparrows with Bamboo*,
mid-nineteenth century. *Surimono* woodblock print, colours on paper

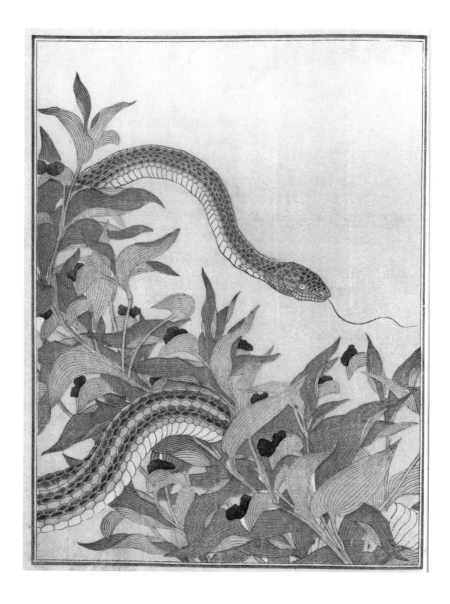

hebi nigete *ware wo mishi me no* *kusa ni nokoru*

after the snake flees
the eyes that glared at me
remain in the grass

Kyoshi

草
に
残
る

我
を
見
し
眼
の

蛇
逃
げ
て

hebi nigete *yama shizuka nari* *yuri no hana*

after the snake flees,
how quiet the forest is!
a lily flower

Shiki

蛇
逃
げ
て

山
静
か
な
り

百
合
の
花

Kitagawa Utamaro (c.1754– 1806), *Snake* (detail), from *Selected Insects*, vol. 2, 1788
Illustrated woodblock printed book, colours on paper

THE DAY MOVES ON . . .

michinobe no mukuge wa uma ni kuwarekeri

the Rose of Sharon
by the roadside
was eaten by my horse

Bashō

samayoeru uma kyōshū to narite kienu

a wandering horse,
turning into a longing
for home, vanishes

Tomizawa Kakio

道野辺の
木槿は馬に
喰はれけり

彷徨へる馬
郷愁となりて
消えぬ

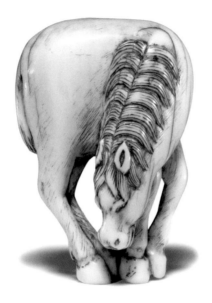

Ji [?illegible signature], *Grazing Horse*, eighteenth–nineteenth centuries
Netsuke, ivory, height 5.3 cm

yuku kari no naku toki chū no kanzerare

passing in the sky
wild geese call; that instant
a feel of the mid-air

Yamaguchi Seishi

行く雁の　啼くとき　中の　感ぜられ

mugi kuishi kari to omoedo wakare kana

the wild geese –
they ate barley, it is true,
but departing –

Yasui

麦喰いし　雁と思えど　別れかな

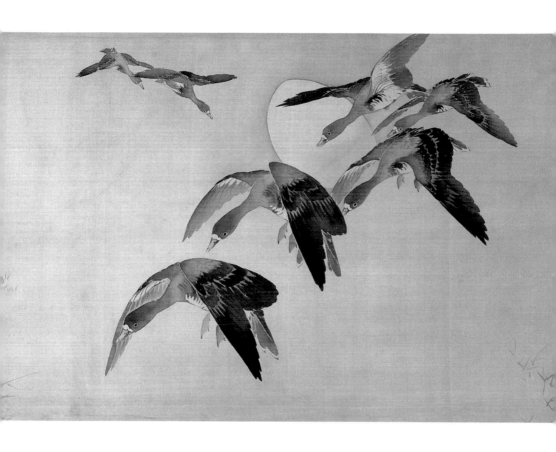

Nishiyama Hōen (1804–1867), *Variety of Birds* (detail), mid-nineteenth century
Handscroll painting, ink and colours on silk

ushi mō mō mō to *kiri kara* *detarikeri*

the cow comes
Moo! Moo!
out of the mist

Issa

牛　も　も
も　う
う　と　霧
　　　　か
　　　　ら
　　　　出
　　　　た
　　　　り
　　　　け
　　　　り

neushi to mo *ishi to mo miete* *kusa moyuru*

A sleeping cow?
A boulder? It could be either.
Grass sprouts out

Kawahigashi Hekigodō

寝牛とも
石とも見えて
草萌る

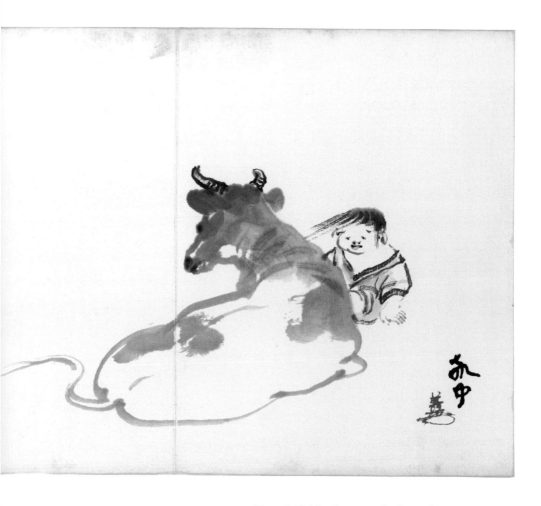

Yamada Keichū (1868–1934), *Cow and Boy*, 1912
Paintings and calligraphy, folding album, ink on paper

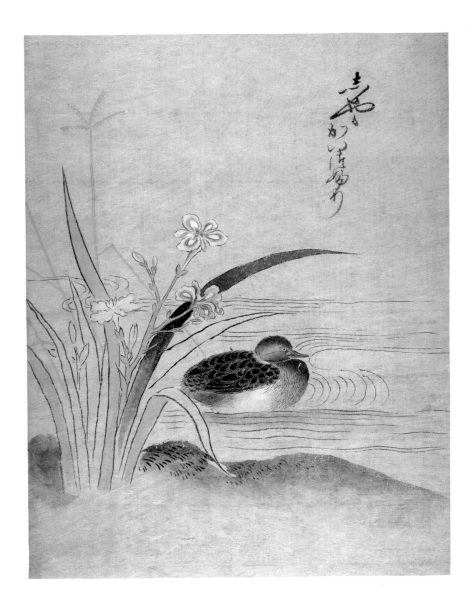

mizutori no mune ni kuchibashi oku ukine kana

the water-fowl
lays its beak on its breast
and sleeps as it floats

Ginkō

水鳥の
胸に嘴置く
浮寝かな

kaitsuburi sabishiku nareba kugurikeri

the grebe
when it becomes lonely
dives into the water

Hino Sōjō

かいつぶり
さびしくなれば
くぐりけり

Anon., *Grebe on the Water with Irises*,
?early nineteenth century
Ink and colours on paper

mozu no iru nonaka no kui yo kannazuki

there the shrike sits
dismal on a stake in the field
the first month of winter

Ranran

百舌鳥の居

野中の杭よ

十月

mozu naku ya irihi sashikomu mematsubara

the shrike cries out
the sinking sun sheds golden light
on a stand of red pines

Bonchō

百舌鳥鳴くや

入日さし込む

女松原

Katsushika Hokusai (1760–1849), *Shrike and Siberian Bluetail with Strawberries*,
late eighteenth–early nineteenth centuries. Woodblock print, colours on paper

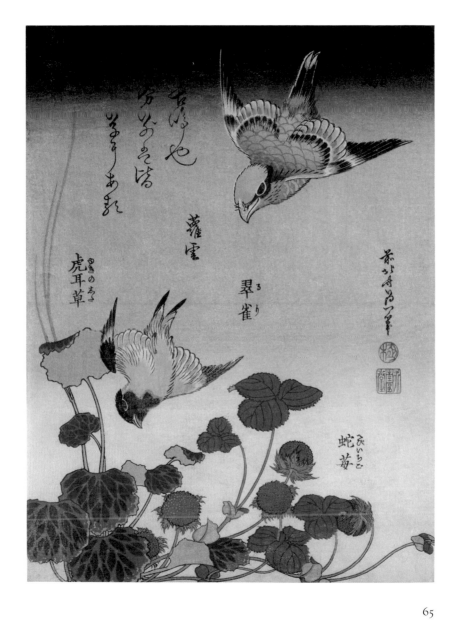

虎耳草

翠雀

蛇苺

65

EVENING

shin to shite *kawasemi tobu ya* *yama no ike*

the stillness:
a kingfisher flies
over the mountain lake

Shiki

しんとして

かわせみ飛ぶや

山の池

kawasemi ya *nureha ni utsuru* *yūhikage*

the kingfisher;
on its wet feathers
shines the evening sun

Tōri

翡翠や

ぬれ羽にうつる

夕日影

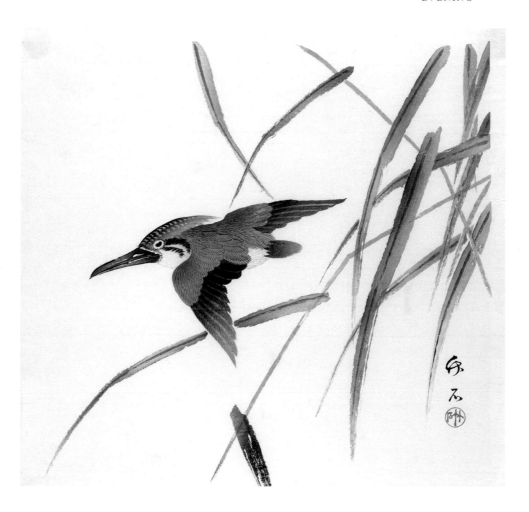

Chikuseki (worked c.1900), *Kingfisher*, c.1900
Woodblock print, colours on paper

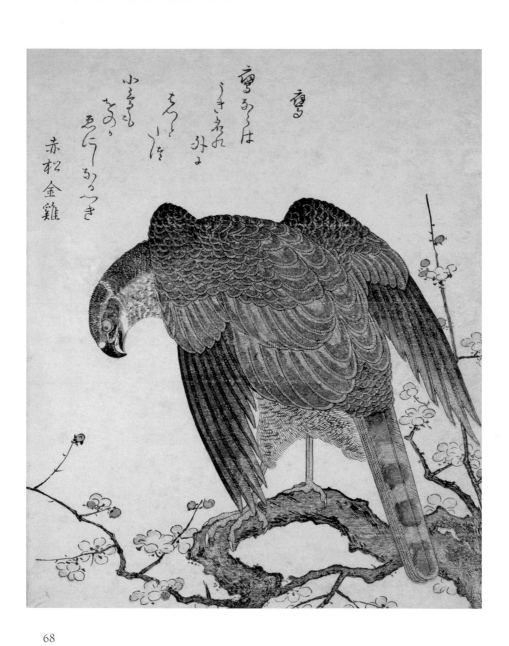

鷹

鷹たゝは
うきれ
をよ
をくし信

小もち
をのゝ
をにちつゝき

赤松金鶏

68

taka no me mo ima ya kurenu to naku uzura

the hawk's eyes
have darkened now:
calling quail

Bashō

鷹
の
目
も
今
や
暮
れ
ぬ
と
鳴
く
鶉

yume yori mo utsutsu no taka zo tanomoshiki

more than dream
the hawk of reality
heartens me

Bashō

夢
よ
り
も
現
の
鷹
ぞ
頼
も
し
き

Kitagawa Utamaro (*c.*1754–1806), *Goshawk* (detail), from *Myriad Birds: A Verse Competition*, vol. 2, *c.*1790. Illustrated woodblock-printed book, colours on paper

kōmori no tobu oto kurashi yabu no naka

the sound of the bat
flying in the thicket
is dark

Shiki

蝙蝠の
飛ぶ音くらし

藪の中

kōmori no kakure sumikeri yaburegasa

the bat
lives hidden
under the broken umbrella

Buson

蝙蝠の
かくれ主みけり

破れ傘

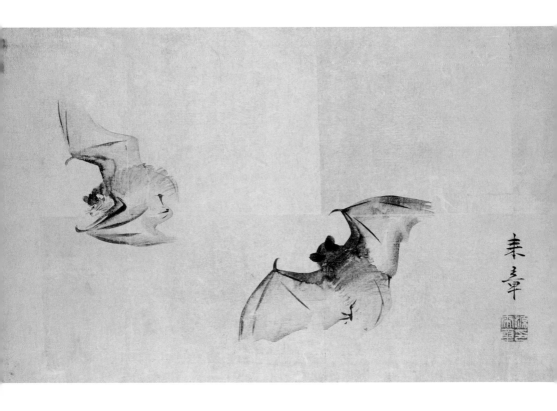

Nakajima Raishō (1796–1871), *Bats and the Moon*, mid-nineteenth century
From a set of four sliding upper doors for a cupboard, ink and gold leaf on paper

tobu ayu no soko ni kumo yuku nagare kana

a trout leaps;
clouds are moving
in the bed of the stream

Onitsura

飛
鮎
の

底
に
雲
ゆ
く

流
れ
か
な

yūgure wa ayu no hara miru kawase kana

in the evening,
the bellies of the trout,
seen in the shallows

Onitsura

夕
暮
は

鮎
の
腹
見
る

川
瀬
か
な

Kinoshita Ōju (1777–1815), *Two Trout in Flowing Water*, c.1800–10
Hanging scroll painting, ink and colours on paper

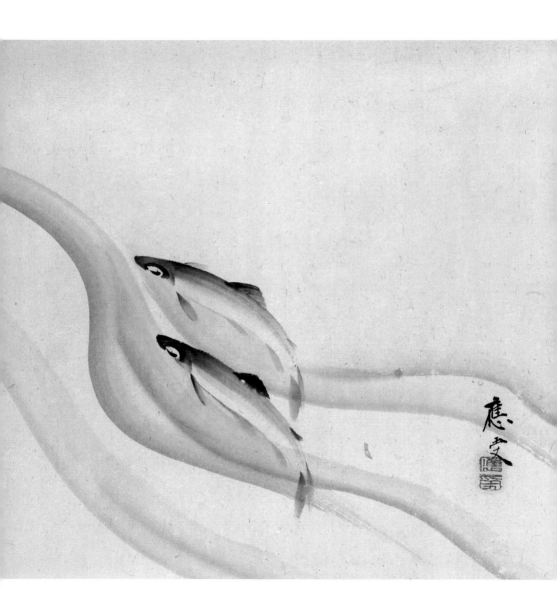

73

teono utsu oto mokobukashi keratsutsu

in the far depths of the forest
the woodpecker
and the sound of the axe

Buson

手斧うつ

音木深し

啄木鳥

kikitsutsuki ya hitotsu tokoro ni hi no kureru

the woodpecker
keeps on in the same place:
day is closing

Issa

啄木鳥や

一つところに

日の暮れる

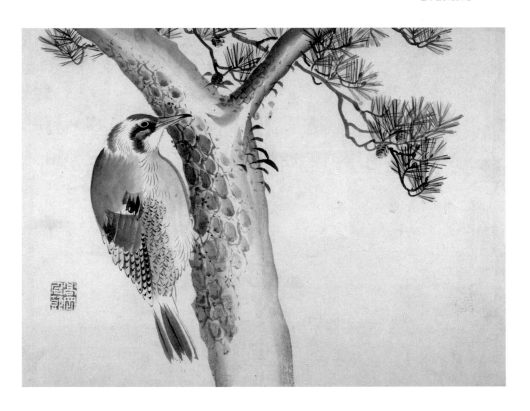

Kōyō (worked mid-nineteenth century), *Green Woodpecker Perched on a Pine Tree*,
mid-nineteenth century. Album leaf painting, ink and colours on paper

tsubakuro ya nani wo wasurete chūgaeri

the swallow
turns a somersault;
what has it forgotten?

Otsuya

中
が
え
り

何
を
忘
れ
て

燕
や

yūtsubame ware ni wa asu no ate mo nashi

ah! evening swallow!
my heart is full of fears
for the morrow

Issa

夕
燕

我
に
は

明
日
の
あ
て
も
な
し

Itō Jakuchū (1716–1800), *Swallow and Poppies*,
late eighteenth century
Pair of six-panel screens, panel 5B, ink on paper

NIGHT FALLS

chichi haha no shikirini koishi kiji no koe

for my father and mother
I yearn so deeply –
a pheasant's cry

Bashō

kiji utte koto no o kireshi yūbe kana

clap of a pheasant's wings
as a string on my *koto*
snaps – and night falls

Seifu

父
母
の

し
き
り
に
恋
し

雉
の
声

雉
子
う
っ
て

琴
の
緒
き
れ
し

夕
か
な

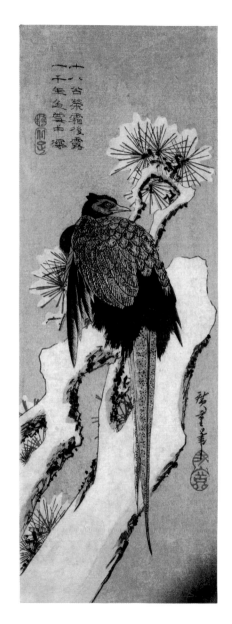

Utagawa Hiroshige (1797–1858),
Pheasant on Snowy Pine Branch, *c*.1835
Woodblock print; colours on paper

yo no naka wa naku mushi sae mo jōzu heta

even among the insects, in this world,
some are good at singing,
some bad

Issa

世の中は
なく虫さへも
上手

下手

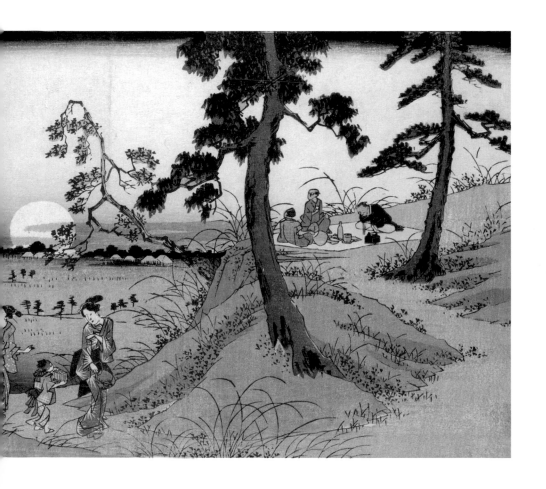

Utagawa Hiroshige (1797–1858), *Listening to Insects at Dōkan-yama* (detail), *c*.1838–42
Woodblock print, colours on paper

kago kara hotaru hitotsu hitotsu wo hoshi ni suru

from the cage
fireflies
one by one
turn into stars

Ogiwara Seisensui

星
に
す
る

一
つ
一
つ
を

ほ
た
る

か
ご
か
ら

hotarumi ya sendō youte obotsukana

firefly viewing —
the boatman is drunk,
the boat unsteady

Bashō

船
頭
酔
う
て

お
ぼ
つ
か
な

蛍
見
や

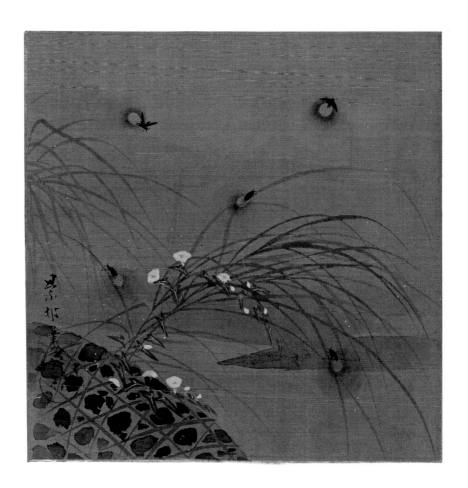

Mizugami Keison (worked early nineteenth century), *Fireflies and Arrow-wort*,
early nineteenth century. Album leaf sketch, ink and colours on silk

kumo korosu ato no sabishiki yosamu kana

after killing a spider
how lonely I feel
in the cold of night!

Shiki

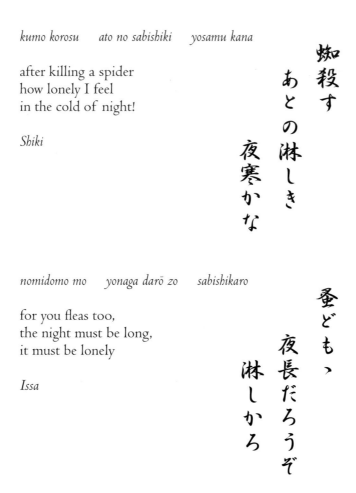

nomidomo mo yonaga darō zo sabishikaro

for you fleas too,
the night must be long,
it must be lonely

Issa

Tanaka Haruhiko (b.1946), *Spider on Aubergine*, 1979
Iron, gold, platinum and diamonds, height 23 cm

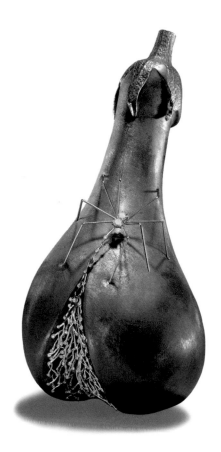

bii to naku shirigoe kanashi yoru no shika

crying 'beeee'
the lingering sound so sad:
night deer

Bashō

夜
の
鹿

尻
声
悲
し

び
い
と
啼
く

shika no tsuno mazu hitofushi no wakare kana

deer horns
developing their first branch:
our separation

Bashō

別
れ
か
な

ま
ず
一
節
の

鹿
の
角

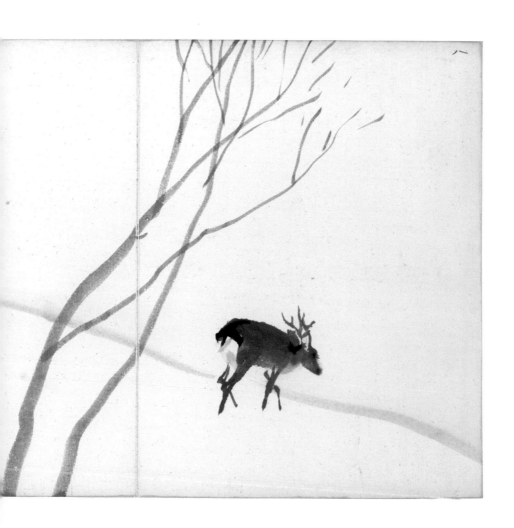

Kawai Gyokudō (1873–1957), *Stag*, 1912
Paintings and calligraphy, folding album, colours on paper

ōki inu tachi mukaetaru satsuki yami

the gigantic dog
rises to receive a guest
in the darkness of May

Mizuhara Shūōshi

巨き犬
立ち迎へたる
五月闇

Masanao (or School of Masanao), *Dog*, nineteenth century
Netsuke, ivory, height 4.8 cm

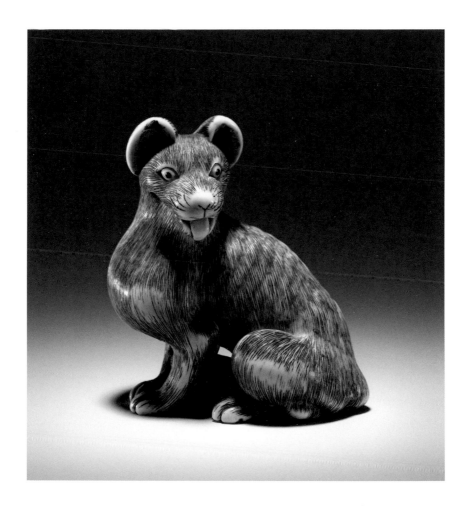

14/50 "背のび する 猫" T. Inagaki '63

nete okite ōakubi shite neko no koi

awaking from sleep,
yawning, stretching, slinking out
in search of love: cat

Issa

大欠して
猫の恋

寝て起きて

Inagaki Tomoo (1902–1980), *Stretching Cat*, 1963
Woodblock print, colours on paper

BIOGRAPHIES OF POETS

Names are given in the order of family name followed by haiku name or given name.

The seventeenth and eighteenth centuries

Matsuo Bashō (1644–1694) was born in Ueno, in Iga province, the son of a low-ranked samurai. As a young man he participated in *renga* gatherings with his lord's son. He decided to become a master poet and moved to Kyoto and later to Edo (Tokyo) where he attracted a following of devoted students. They provided him with a house shaded by a banana tree (*bashō*) from which he took his poetry name. He led an austere life, from the early 1680s making several journeys on foot, producing prose and poetry diaries, the most famous of which is *The Narrow Road to the Deep North*. Bashō's protégés came from far and wide and were a varied group – samurai, merchants, physicians and members of the lower classes. Some were Edo men, such as **Enomoto Kikaku** (1661–1707), the son of a physician who did not always see eye to eye with Bashō. **Nozawa Bonchō** (died 1714) moved to Edo from Kanazawa to practise medicine. He was a man of strong character and made a significant contribution to *renga*. He and Kikaku are often considered to be the most outstanding poets of Bashō's circle. **Shitarigao Keiseki** (dates unknown) was also an Edo man. Others who joined Bashō in Edo were **Matsukura Ranran** (1647–1693), a straightforward character who became very close to the master, and **Okada Yasui** (1632–1710), a wealthy merchant from Nagoya who joined Bashō's *renga* gatherings. **Kawai Sora** (1649–1710), a samurai from Nagano, accompanied Bashō to the Deep North, keeping a diary which gives an interesting view of how Bashō worked. **Esa Shōtaku** (1650–1722), a physician born in Ise, was already a well-known poet when he visited Bashō in Edo, and may have disagreed with him over his later stylistic development. **Uejima Onitsura** (1661–1738), renowned for his sincerity, was involved in early experimentation in haiku writing. Buson painted his portrait. Very little is known of **Yūkihagi Tōri** (?fl. 1704–1718), from Osaka. Among the outstanding women poets was **Shiba Sonome** (1664–1726), born in

Ise. Her husband was also a poet, but she was an independent character who moved alone to Edo after his death, and produced two substantial anthologies.

Some years after Bashō's death there was a haiku revival led by **Yosa Buson** (1716–1783), especially after he settled in Kyoto in 1751. He was born near Osaka, the son of a farmer. A fine painter with an eye for colour and drama, for much of his life he made his living from his brush. He also travelled widely and was much influenced by Bashō, *haikai* and by Chinese poetry. **Kobayashi Issa** (1763–1827) had much difficulty and sadness during his life. This is reflected in his haiku, though there is also wry humour and a kindly sympathy with all creatures, however tiny. The son of a middle-class farmer in central Japan, he studied haiku in Edo. However, he preferred travelling and teaching, until his father's last illness brought him back to his home village where he spent the rest of his life. **Miura Chora** (1729–1780), born in Shima province, was a friend of Buson and was deeply involved in the revival movement, favouring a clear, simple style. **Enomoto Seifu** (1732–1815) was a samurai's daughter and had a good education. She was encouraged to write by her stepmother, also a haiku poet. As a widow she wrote profusely and her collected haiku were published posthumously by her son. She is sometimes compared to Buson for the dramatic qualities of her poems. Other comparatively unknown poets from this period are **Otsuya** (dates unknown) who led the Ise school in the early eighteenth century, his pupil **Bakusui** (1770–1783), a merchant, and **Ginkō** (died 1857) who wrote many books.

The haiku revival: nineteenth, twentieth and twenty-first centuries

In his short life beset by illness, **Masaoka Shiki** (1867–1902) nevertheless succeeded in rescuing haiku from the degradation it had suffered since the death of Buson. He urged poets to seek inspiration from the beauty of nature, preferring Buson to Bashō: 'Encounter beautiful scenes and copy them realistically.'

After Shiki's death, **Kawahigashi Hekigodō** (1873–1939) led the reform movement. The first of the radicals, he was inventive, discarding the 5-7-5 form but keeping the season word, as he saw the change of seasons as a constant in

the universe. **Ogiwara Seisensui** (1884–1976) even rejected the season word, working with symbols, while **Ozaki Hōsai** (1885–1926), his student, lived simply, working in temples and writing in a free, meditative style

There was a marked return to conservatism under **Takahama Kyoshi** (1874–1959), the dominant figure in the first half of the twentieth century. He insisted on the regular form and the *kigo* as an essential basis for haiku, seeking inspiration from its classical origins and the melancholy spirit of Japanese culture. **Tomiyasu Fūsei** (1885–1979) wrote haiku while working as a successful civil servant. He thought that everybody should write and enjoy poetry, and his haiku have a down-to-earth clarity which has immediate impact. Two friends of Kyoshi, well-known novelists **Natsume Sōseki** (1867–1916) and **Akutagawa Ryūnosuke** (1892–1927), also wrote haiku. Sōseki's novels are based on realistic naturalism and writing haiku allowed him to view the world in a more detached way. Akutagawa admired Bashō, but was an independent spirit developing his own imaginative and striking images.

A reaction took over as the twentieth century progressed, with many poets influenced by modernisation, industrialisation and urban living. **Hino Sōjō** (1901–1956) favoured 'faithfulness to self', introducing new elements of romantic love and sensuality which shocked many. The young physician **Mizuharu Shūōshi** (1892–1981) was also a reactionary, but he saw poetry as a chance to develop the imagination with grace and beauty. **Yamaguchi Seishi** (1901–1994), a supporter of Shūōshi, was an individualist looking for new material and depth of feeling. His haiku reflect the harshness of industrial life. These three were young city workers for whom poetry was the focus of their lives.

There were still humanist poets such as **Nakamura Kusatao** (1901–1984) who stressed the importance of tradition and the poet's quest for moral perfection. The writing of **Katō Shūson** (1905–1993) reflects his hard life supporting his mother and siblings. Their poetry, complex, often obscure and introspective, influenced many other writers.

After the war, poets keenly appreciated their new freedom. For **Tomizawa Kakio** (1902–1962), the poem had a life of its own, removed from everyday life. His haiku, often influenced by his war experiences in China, have great

originality and mystery, full of outlandish images. **Kaneko Tōta** (born 1919) accepts the 5-7-5 structure as a finality 'in this life [where] nothing is final', while regarding the *kigo* as obsolete in modern life. Described as an avant-garde poet, he writes about political and social problems in a highly creative, often startling style.

The writing of haiku continues to flourish, spreading worldwide. Poets appreciate the 'finality' of the form, which enables them to capture striking experiences, sights or events in sharp relief and to share their inward life in a creative way.

SOURCES OF TRANSLATIONS

Barnhill, D.L. 2004: *Bashō's Haiku: Selected Poems of Matsuo Bashō*, State University of New York, pp. 10 (bottom), 14 , 32 (bottom), 36, 41 (bottom), 69, 78 (top), 82 (bottom), 86

Blyth, R.H., (1949–1952): *Haiku* (4 vols), Hokuseido Press, Japan, pp. title page, 7, 10 (top), 12 (top), 18 (top), 21, 22 (bottom), 24 (top), 28 (top), 31, 32 (top), 35 (bottom), 38 (top), 56 (top), 58 (bottom), 60 (top), 63 (top), 66, 70, 72, 74, 76, 80, 84 (bottom)

Bownas, Geoffrey and Thwaite, Anthony, authors and translators. 1998: *The Penguin Book of Japanese Verse*, Penguin Books, Ltd., London, 1994 pp.12 (bottom), 42 (top), 52 (top)

Miner, Earl and Odagiri, Hiroko. 1981: *The Monkey's Straw Raincoat, and Other Poetry of the Bashō School*, Princeton University Press, USA. pp. 17, 28 (bottom), 49 (top), 50, 64

Ueda, Makoto. author, editor, translator. (1976): *Modern Japanese Haiku: An Anthology*, reprinted with permission of University of Toronto Press, Canada. pp. 8, 18 (bottom), 22 (top), 24 (bottom), 26 (by kind permission of the poet, Kaneko Tōta), 38 (bottom), 42 (bottom), 44, 46, 49 (bottom), 52 (bottom), 55, 56 (bottom), 58 (top), 60 (bottom), 63 (bottom), 82 (top), 84 (top), 88, (from Shūōshi's anthology *Zanshō*, 1952), back cover

Ueda, Makoto, author, editor, translator. (2003): *Far Beyond the Field: Haiku by Japanese Women*, reprinted with permission of Columbia University Press. pp. 35 (top), 78 (bottom)

41 (top), 91 Mavis Pilbeam

ILLUSTRATION REFERENCES

Page
2 1979,0305,0.325
3 1994,0516,0.1, donated by Karel Reisz
8 1950,1111,0.18, donated by Trustees of James Martin White
11 2004,0623,0.1
13 1881,1210,0.1445
15 1983,1110,0.1
16 1907,0531,0.361
19 1979,0305,152-1
20 1902,0606,0,29.1, bequeathed by Sir AW Franks
23 1906,1220,0.1809
25 1979,0305,152-15
27 1989,0314,0.68
29 1946,0209,0.128
30 1966,0505,0.1, donated by Captain Collingwood Ingram
33 1966,0505,0.1, donated

Page
 by Captain Collingwood Ingram
34 1928,0720,0.35, bequeathed by James Orange
37 1913,0501,0.506.3 donated by Sir William Gwynne-Evans, Bt
39 1979,0305,0.406
40 1913,0501,0.580, donated by Sir William Gwynne-Evans, Bt
43 1979,0305,152-4
45 1998,1109,0.1
47 1983,1111,0.3.1-2
48 1979,0305,152-13
51 1966,0505,0.1, donated by Captain Collingwood Ingram
53 1993,0405,0.16
54 1979,0305,152-10
57 HG.117, donated by Prof John and Ann Hull Grundy

Page
59 1939,1014,0.2
61 1994,1112,0.1
62 1881,1210,0.1123
65 1910,0614,0.26
67 1906,1220,0.1811
68. 1915,0823,0.67.1-2
71 1990,1107,01.1-4
72 1994,1114,0.1
75 1881,1210,0.2412
77 2001,0611,0.1-2
79 1926,0217,0,13
80 1906,1220,0.999
83 1881,1210,0.2418
85 1986,0520,0.1, © the artist
86 1994,1112,0.1
89 F.772, donated by Sir AW Franks
90 1987,0316,0.400, © the estate of the artist
96 2000,0724,0.2
Back cover 1881,1210,0.1871